Herman the Mouse

Written & Illustrated by Tammy (Seebecker) Brown

Archway Publishing books may be ordered through booksellers or by contacting:

Archway Publishing
1663 Liberty Drive
Bloomington, IN 47403
www.archwaypublishing.com
1 (888) 242-5904

Because of the dynamic nature of the Internet, any web addresses or
links contained in this book may have changed since publication and may
no longer be valid. The views expressed in this work are solely those
of the author and do not necessarily reflect the views of the publisher,
and the publisher hereby disclaims any responsibility for them.

ISBN: 978-1-4808-3073-8 (sc)
ISBN: 978-1-4808-3074-5 (hc)
ISBN: 978-1-4808-3072-1 (e)

Library of Congress Control Number: 2016908334

Print information available on the last page.

Archway Publishing rev. date: 6/21/2016

ARCHWAY
PUBLISHING

For Charlie
I hid something just for you on every page of my book.
So turn each colorful page, and carefully take a look.
It's a fuzzy brown spider; with eight legs too,
And two big googly eyes, looking back at you!
Love, Grandma

And
To my husband Curt and my daughter Melissa for the help
and encouragement in finally making a dream come true.

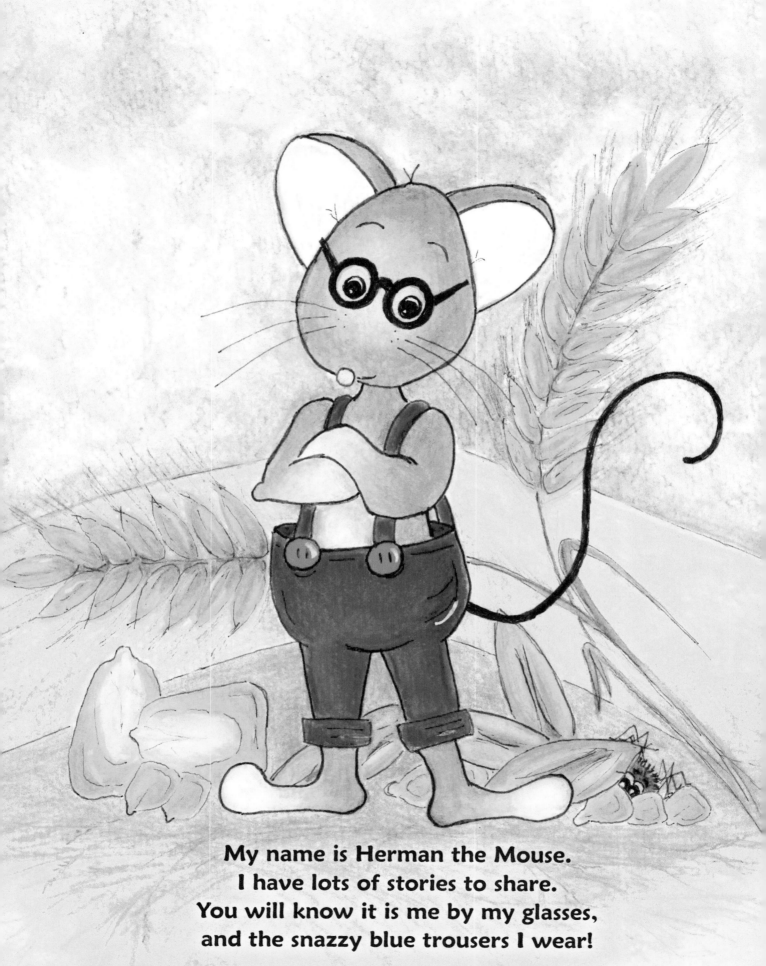

My name is Herman the Mouse.
I have lots of stories to share.
You will know it is me by my glasses,
and the snazzy blue trousers I wear!

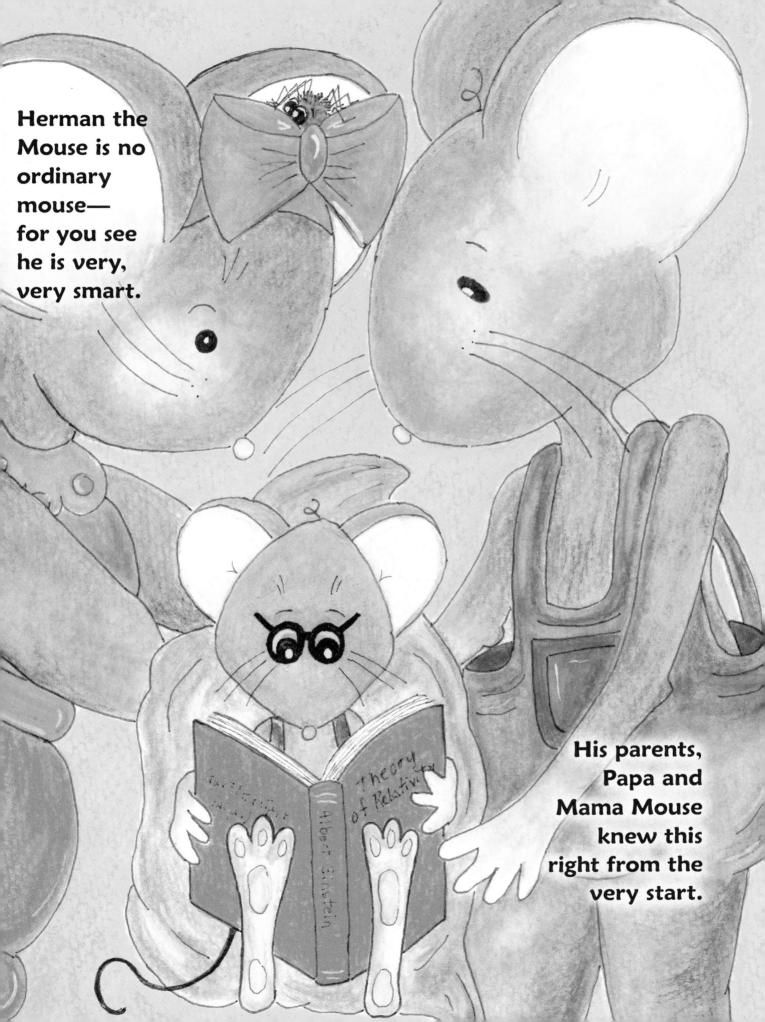

Herman the Mouse is no ordinary mouse— for you see he is very, very smart.

His parents, Papa and Mama Mouse knew this right from the very start.

They live in a pile of straw
in a barn painted red
with the cows, chickens, and sheep,
and a friendly horse named Ned.

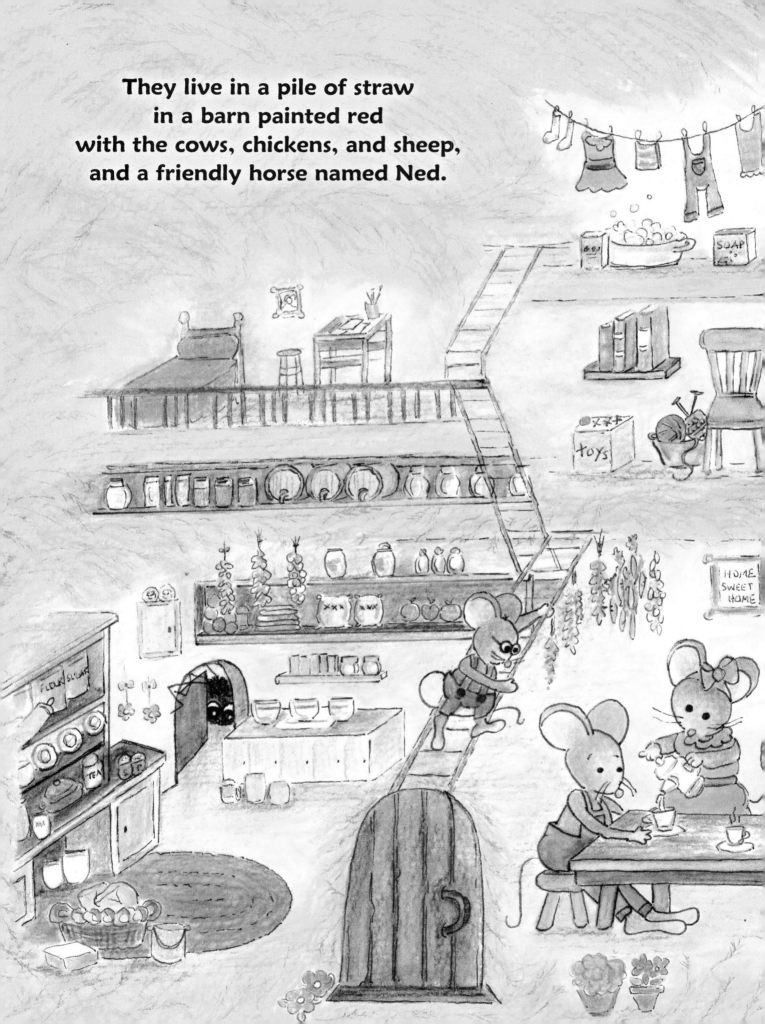

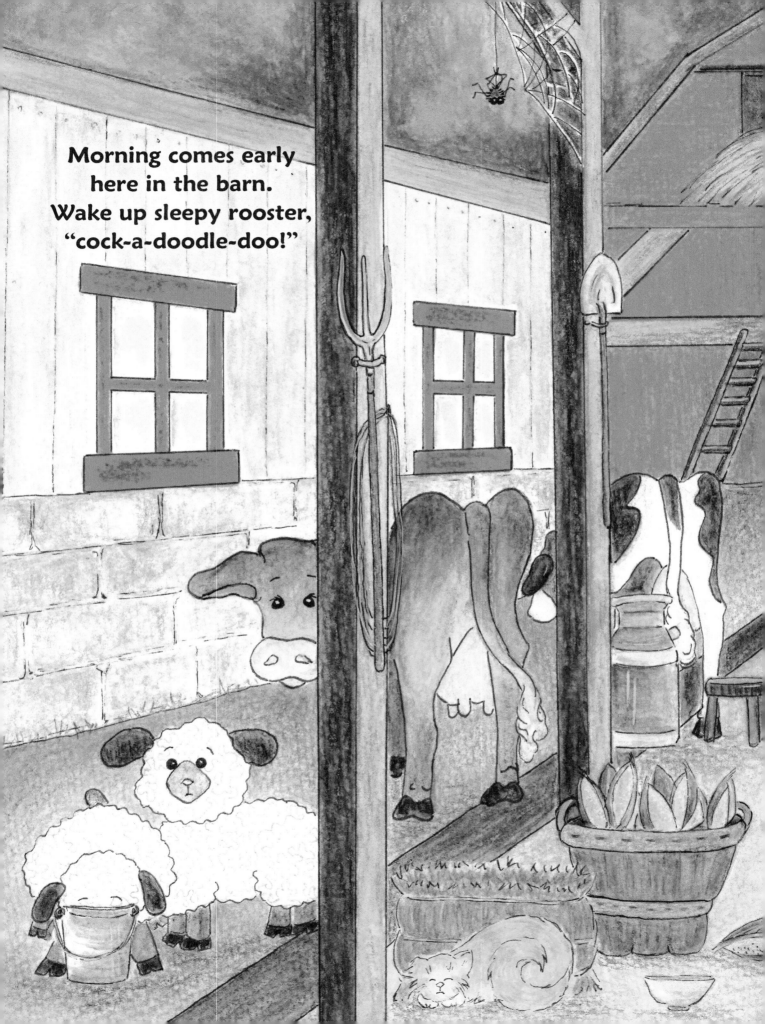

Morning comes early
here in the barn.
Wake up sleepy rooster,
"cock-a-doodle-doo!"

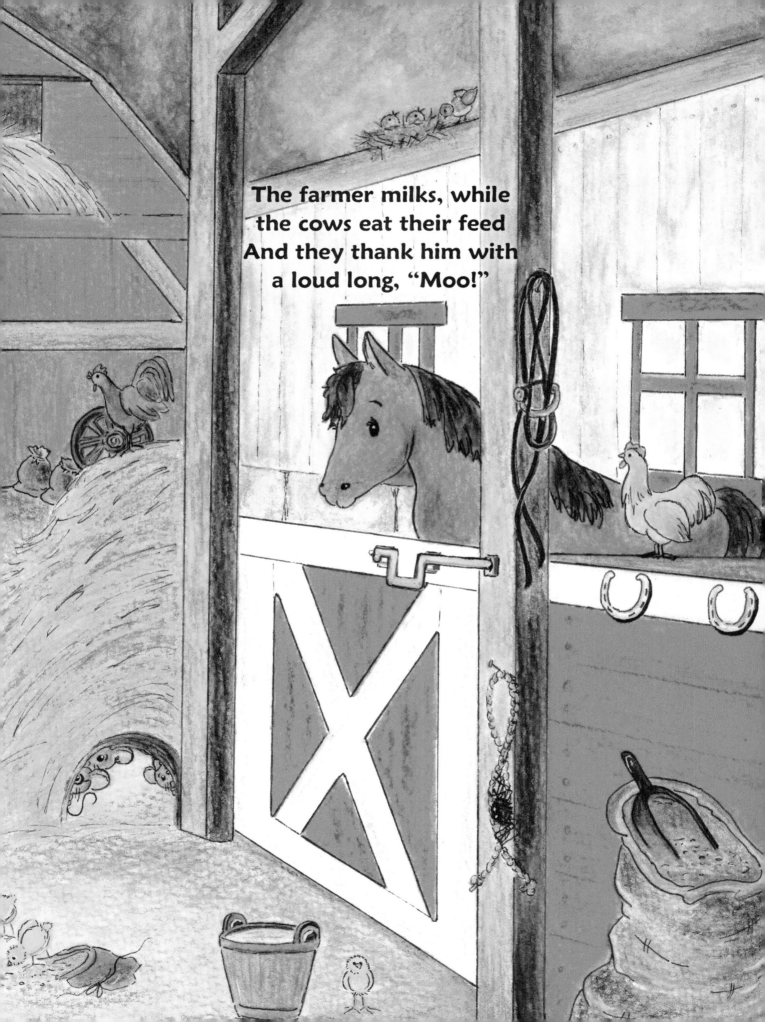

The farmer milks, while
the cows eat their feed
And they thank him with
a loud long, "Moo!"

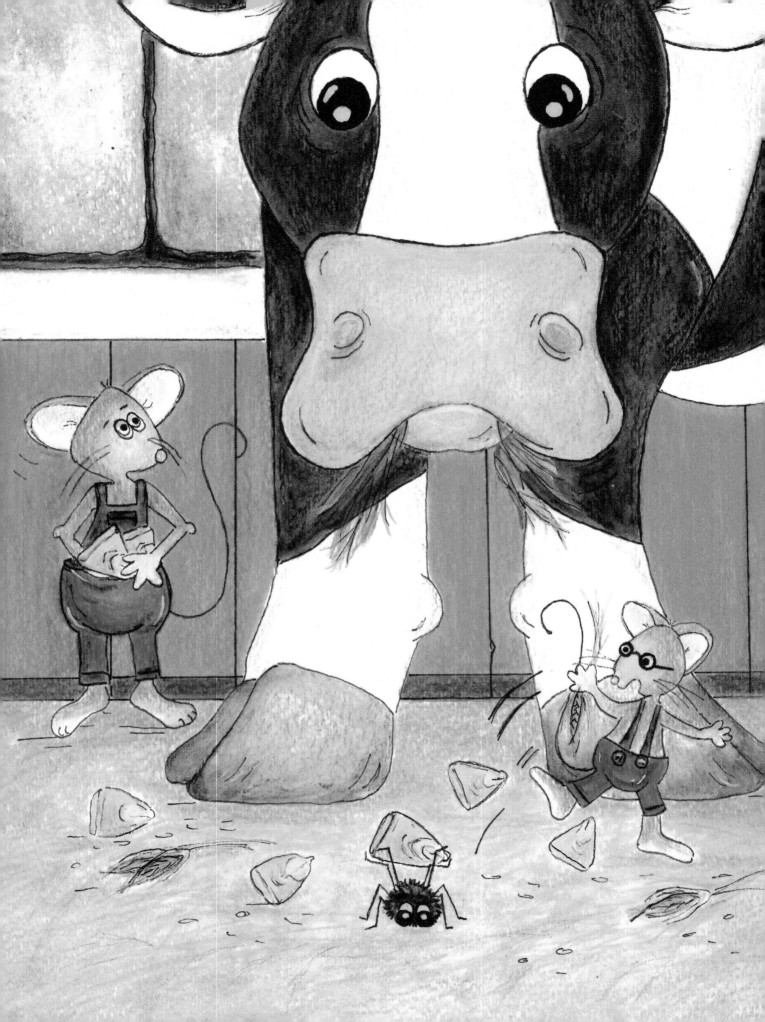

**This is Herman's chance
to grab a delicious treat.
Oh, but be careful of
those huge cow feet!**

Behold in the corner....
something new. What is that?
Over there against the wall—
it's a giant mouse trap!

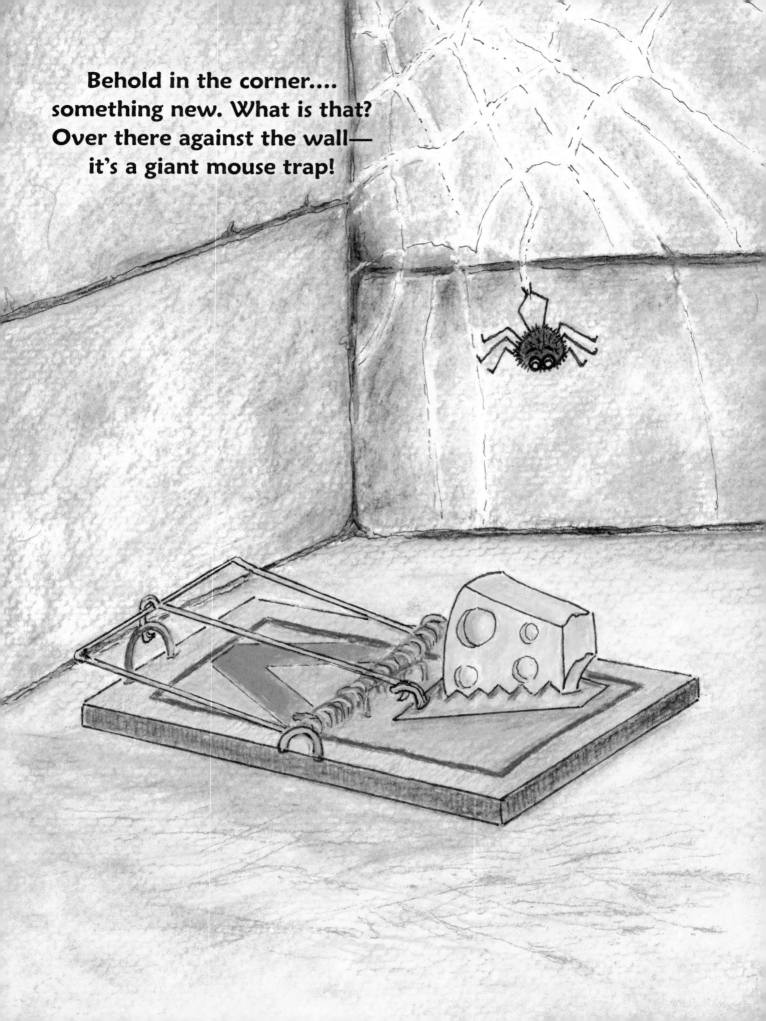

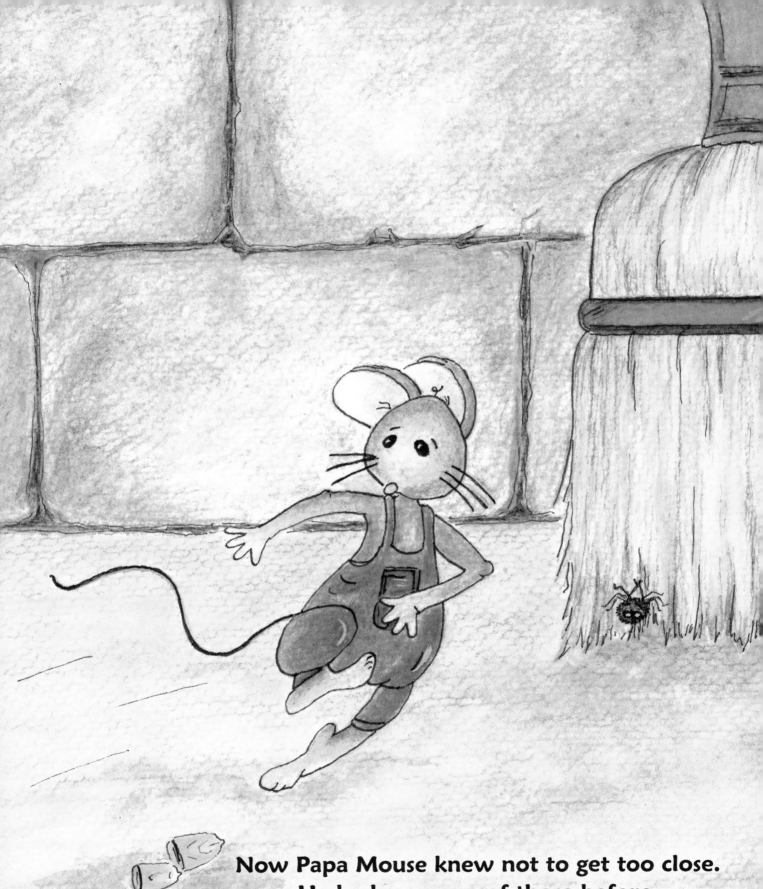

Now Papa Mouse knew not to get too close.
He had seen one of those before.
"This is a sign of trouble," he said,
as he scurried for the door.

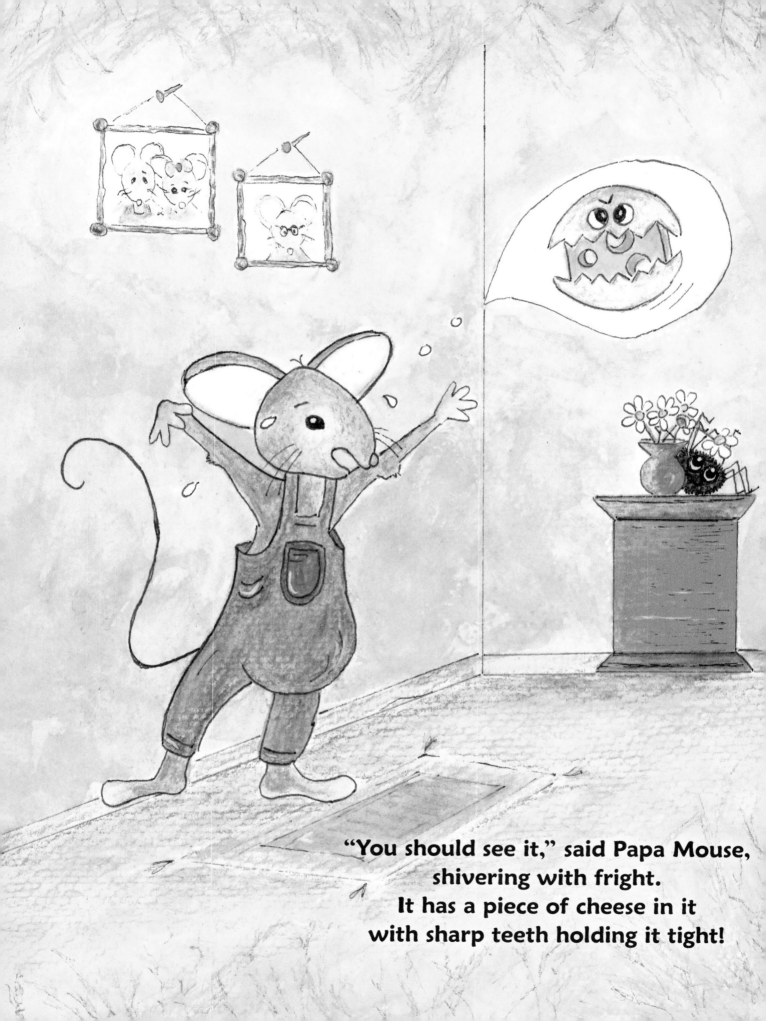

"You should see it," said Papa Mouse,
shivering with fright.
It has a piece of cheese in it
with sharp teeth holding it tight!

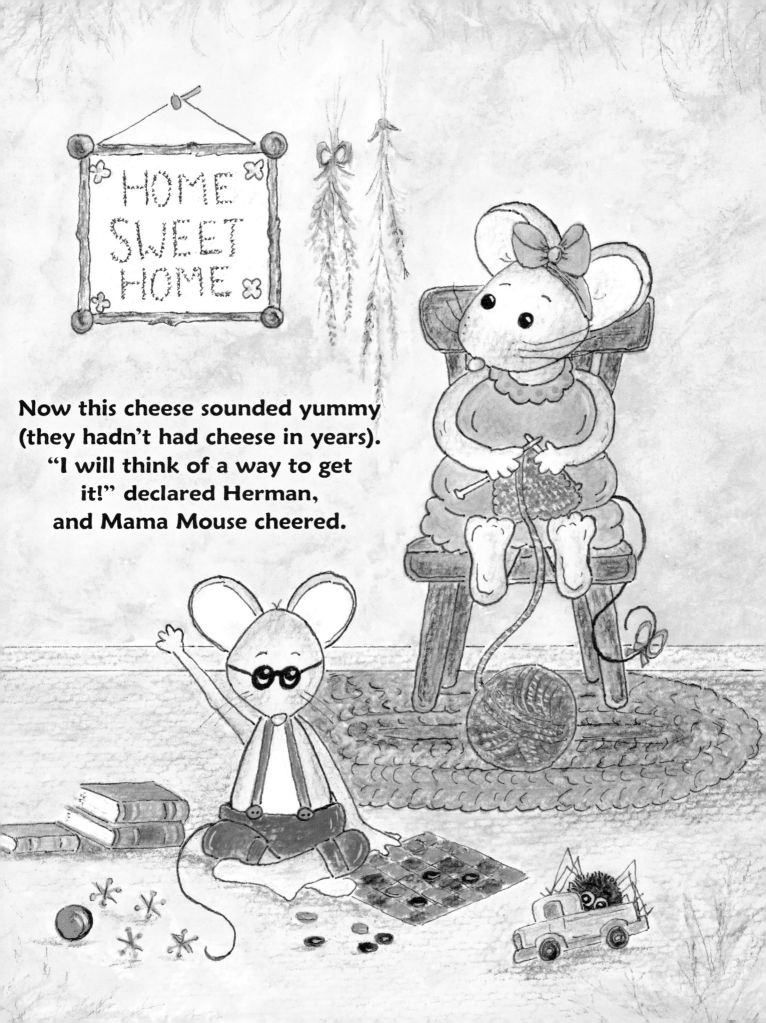

Now this cheese sounded yummy
(they hadn't had cheese in years).
"I will think of a way to get
it!" declared Herman,
and Mama Mouse cheered.

Herman drew up plans. Plan A, B, and C.

And if those didn't work he would combine all three.

Herman worked very hard
and planned well into the night
until he came up with a plan
he knew would work just right.

It was going to be the Trap-inator—
all he needed was a slightly used spring
to lower himself over the cheese,
a stick, and a spool of string.

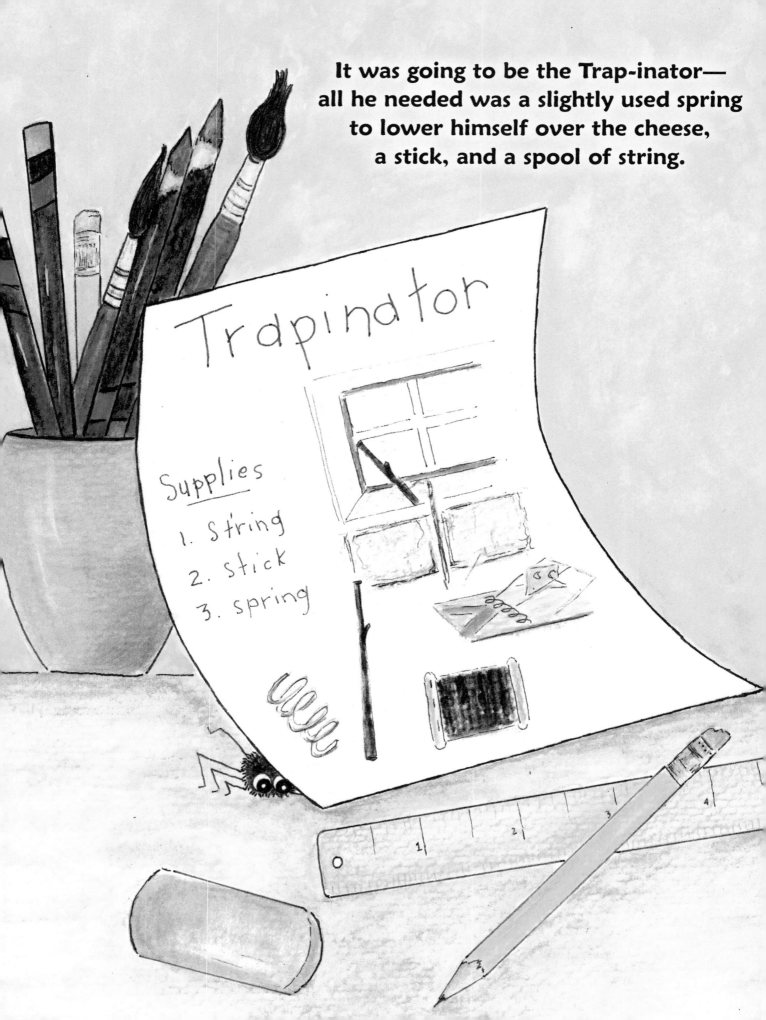

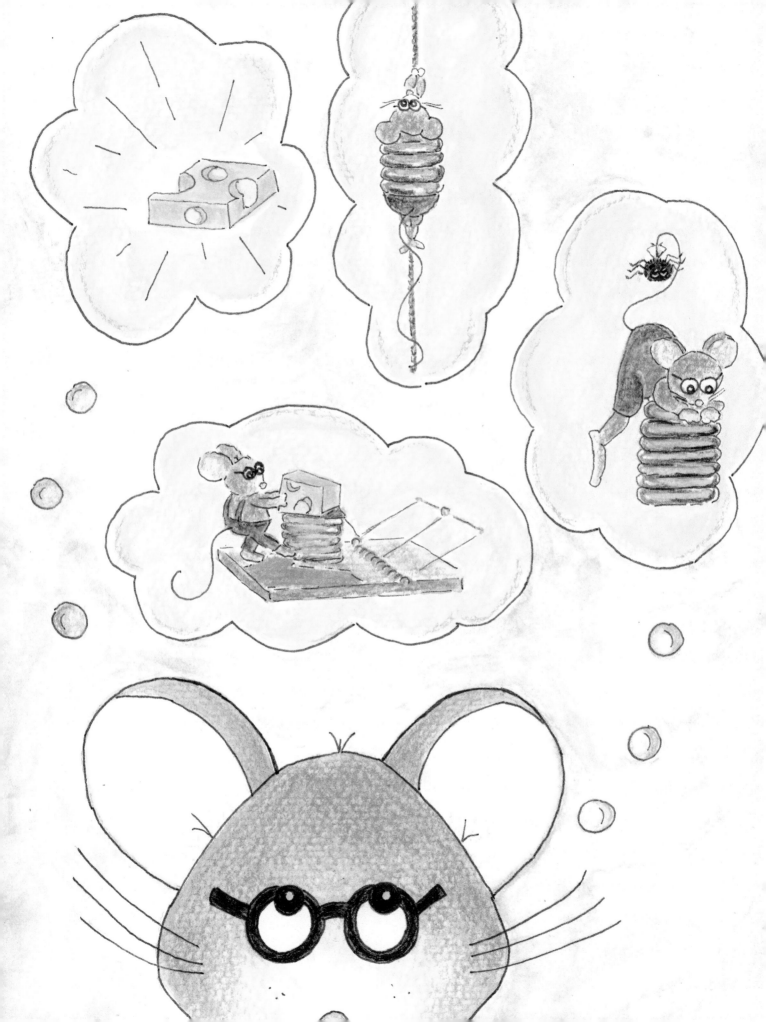

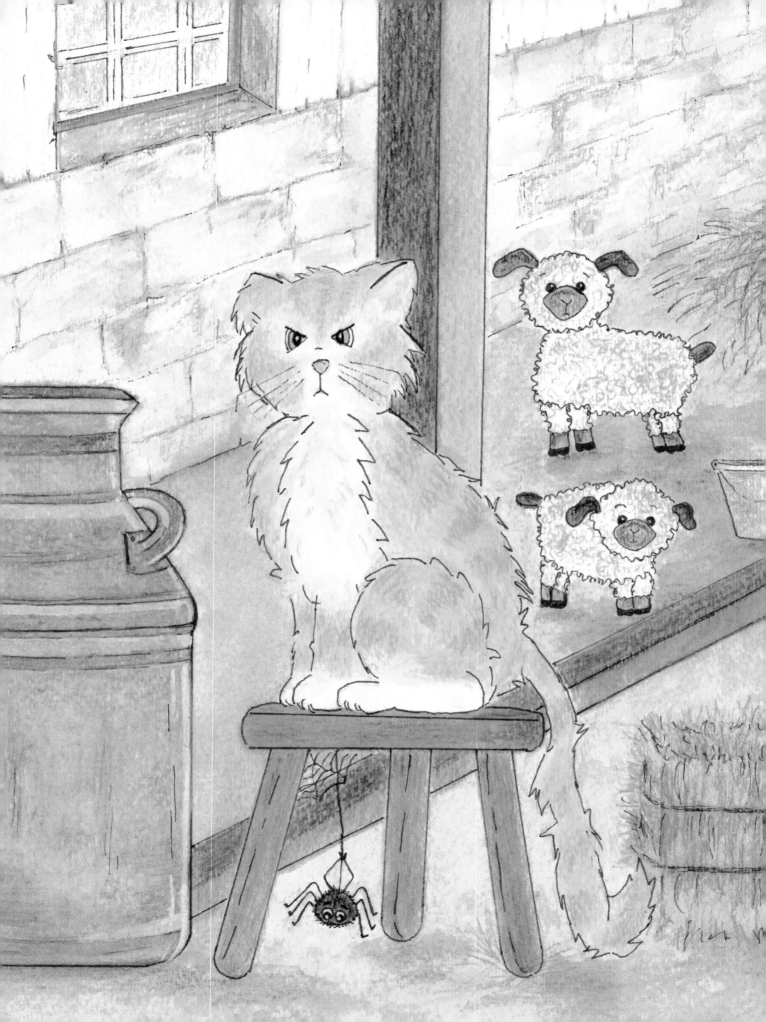

But down in the barn
there's another danger to avoid.
The old tom cat with one ear,
an old tom cat named Lloyd.

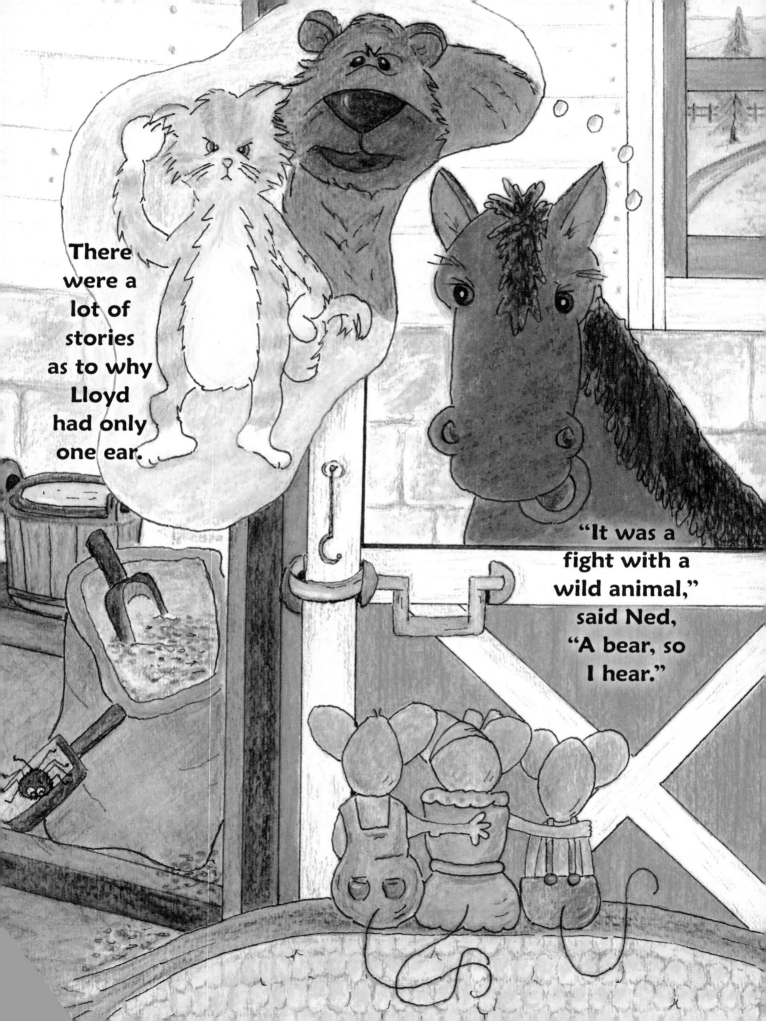

There were a lot of stories as to why Lloyd had only one ear.

"It was a fight with a wild animal," said Ned, "A bear, so I hear."

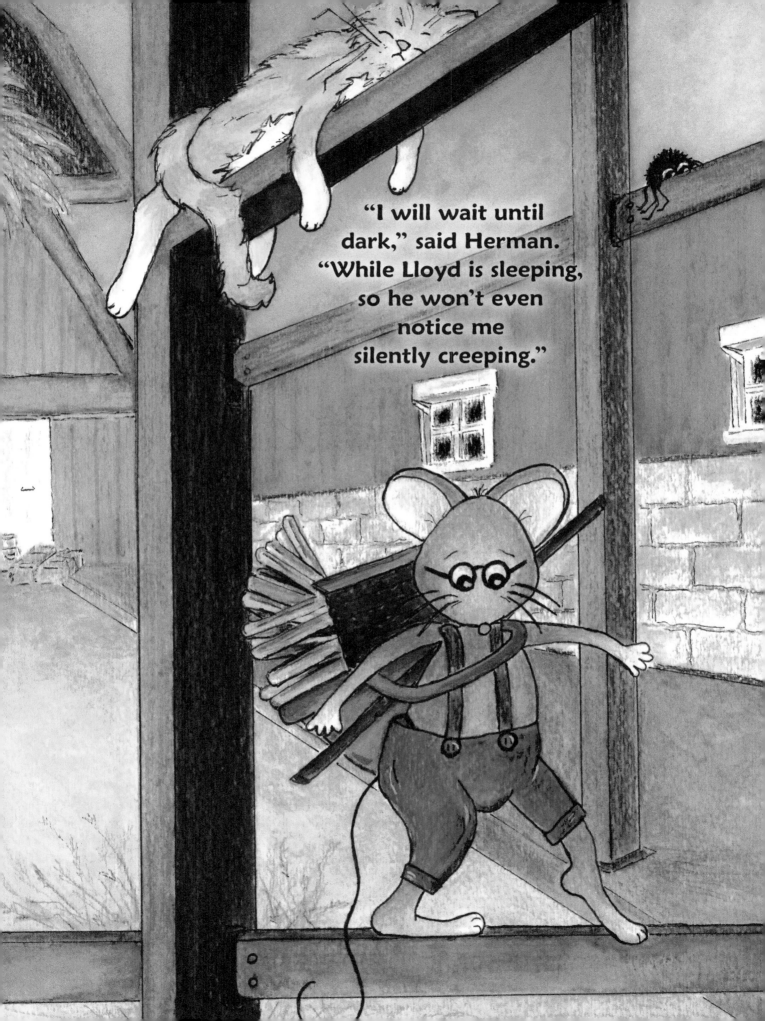

So just before dark
When the barn was quiet and still,
Herman climbed up the wall
and along the windowsill.

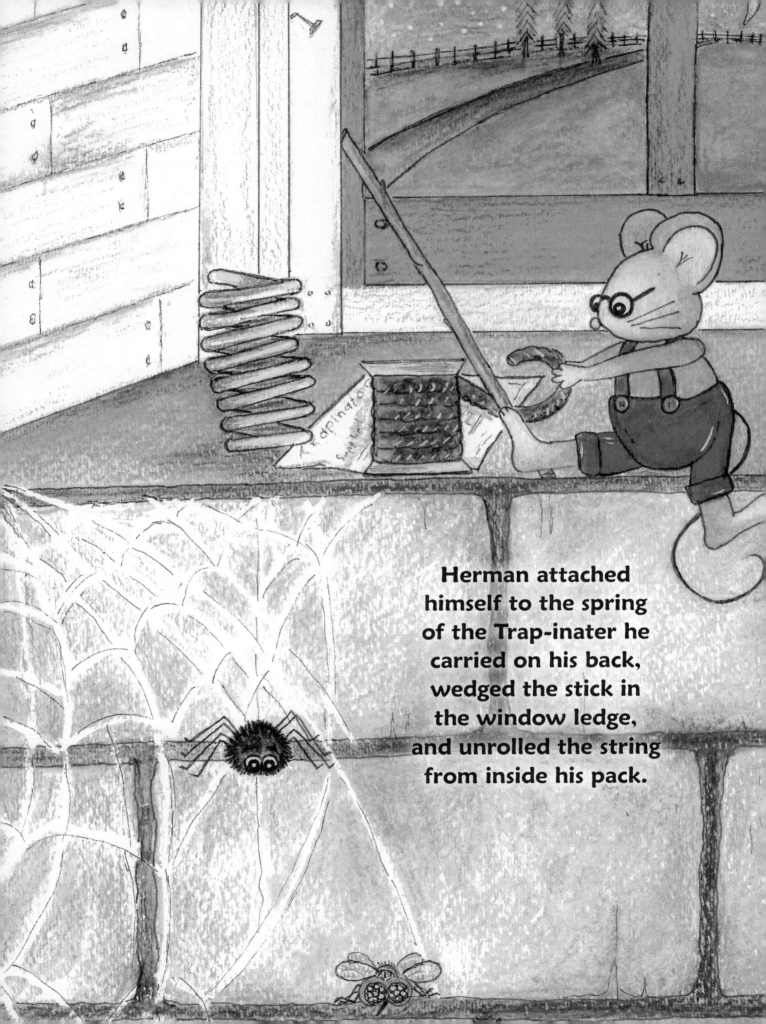

Herman attached himself to the spring of the Trap-inater he carried on his back, wedged the stick in the window ledge, and unrolled the string from inside his pack.

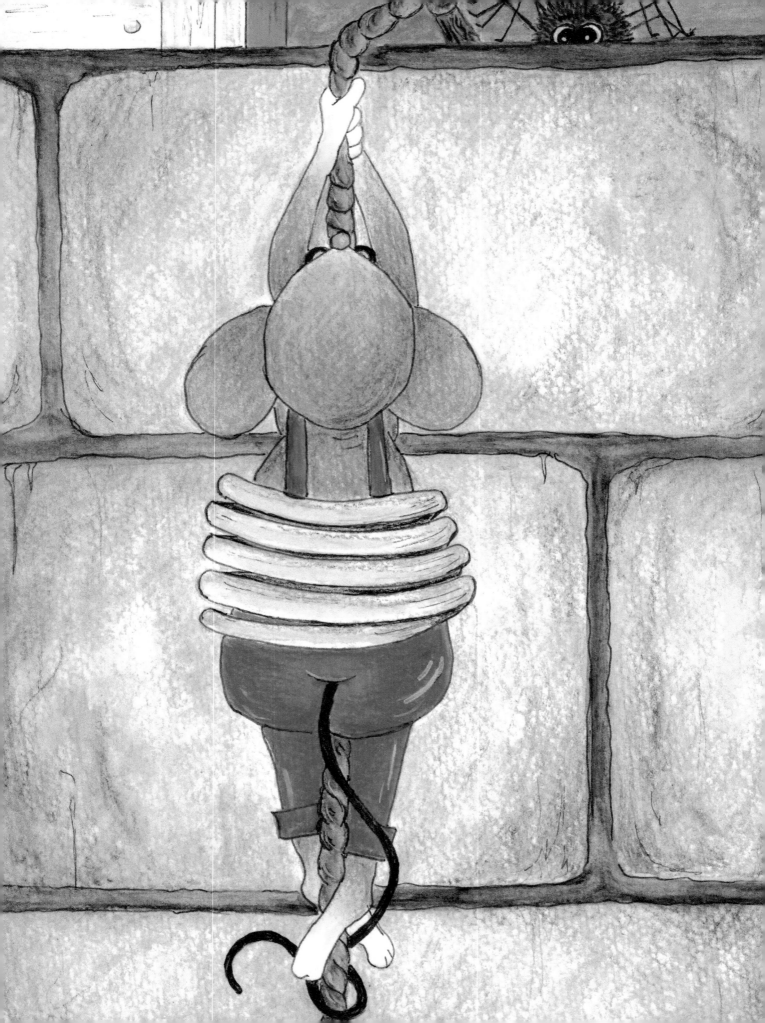

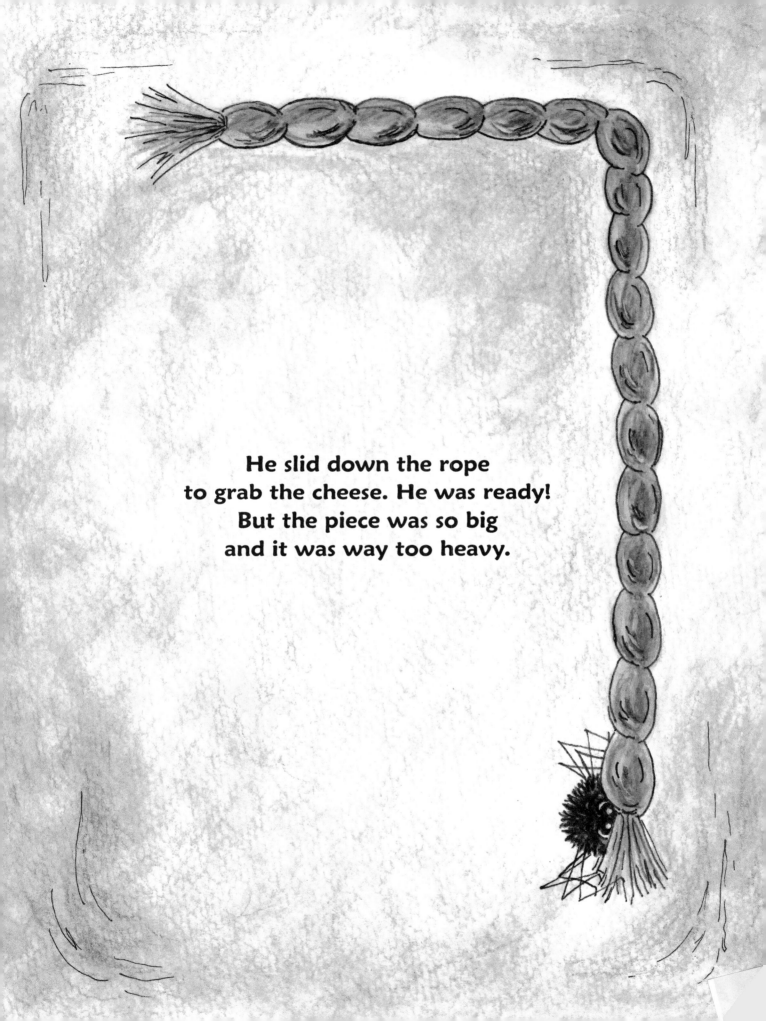

He slid down the rope
to grab the cheese. He was ready!
But the piece was so big
and it was way too heavy.

He wrapped his little arms
around as far as he could.
But when he leaned back to lift it
his foot slipped on the wood.

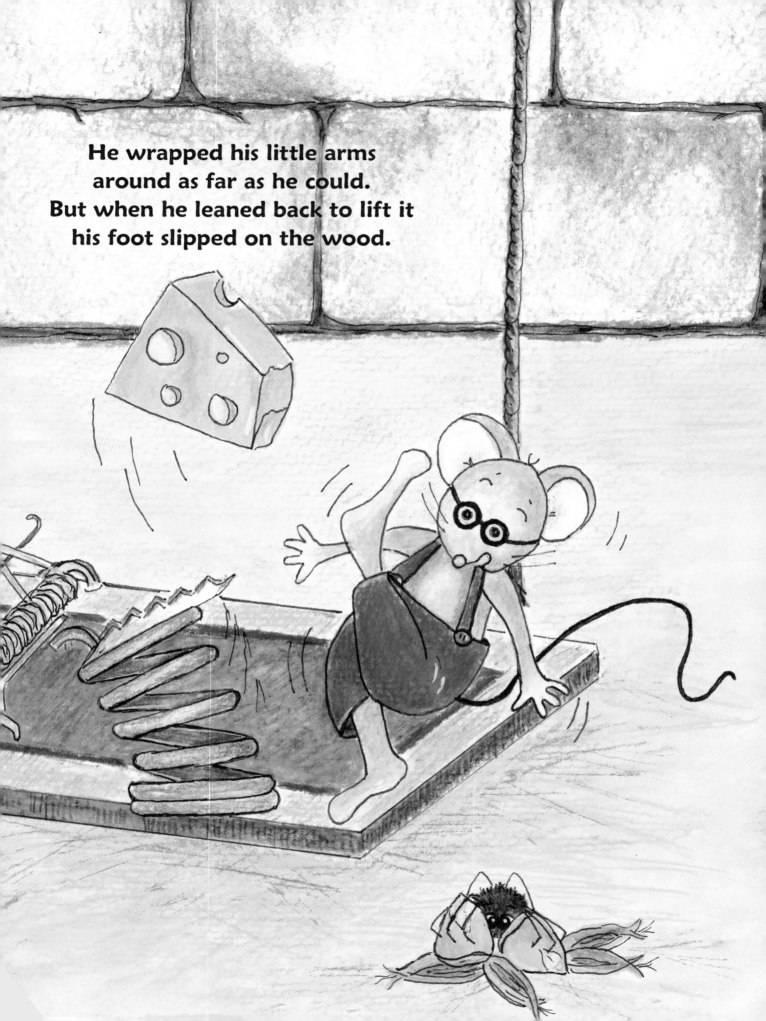

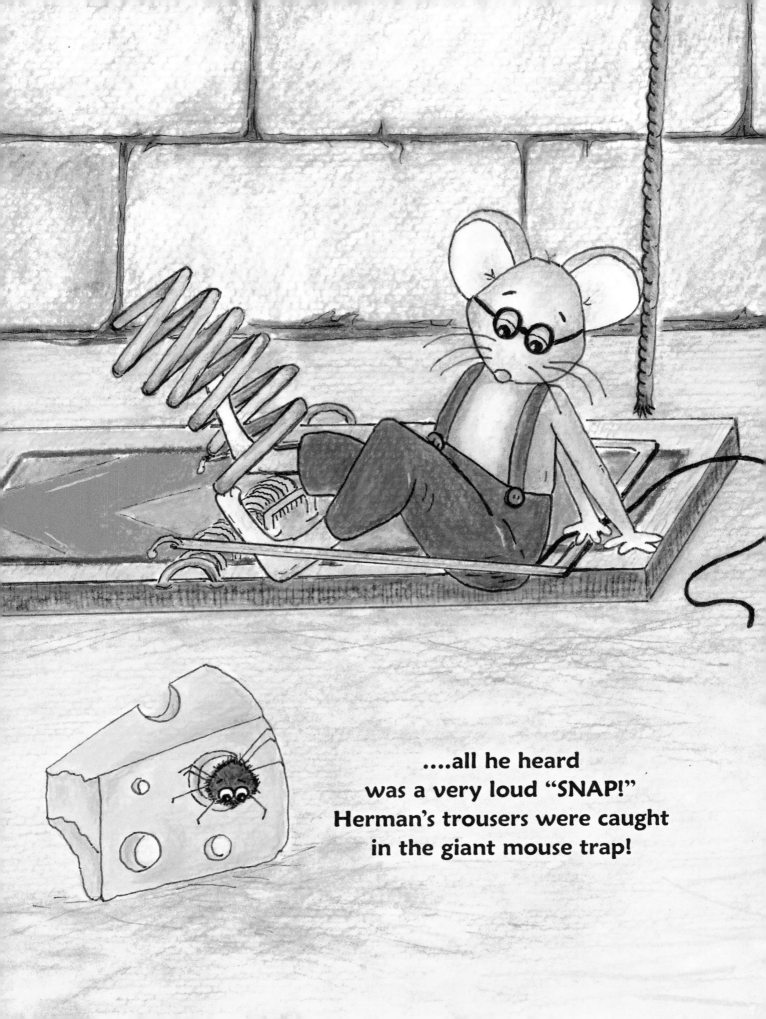

....all he heard
was a very loud "SNAP!"
Herman's trousers were caught
in the giant mouse trap!

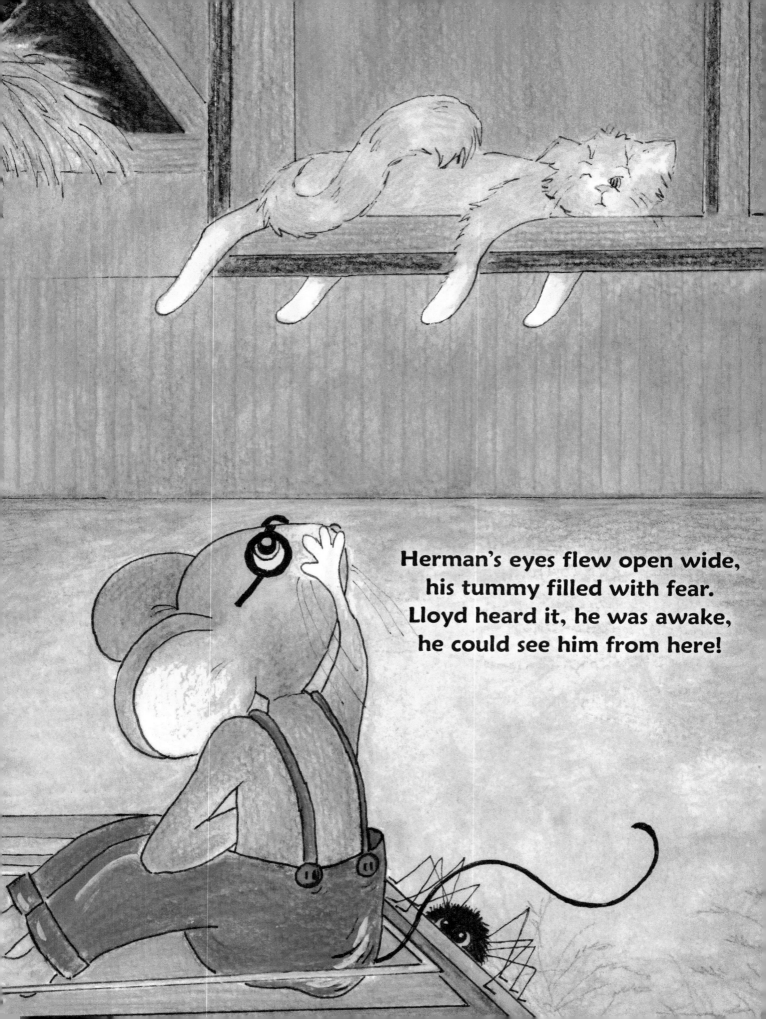

Herman's eyes flew open wide,
his tummy filled with fear.
Lloyd heard it, he was awake,
he could see him from here!

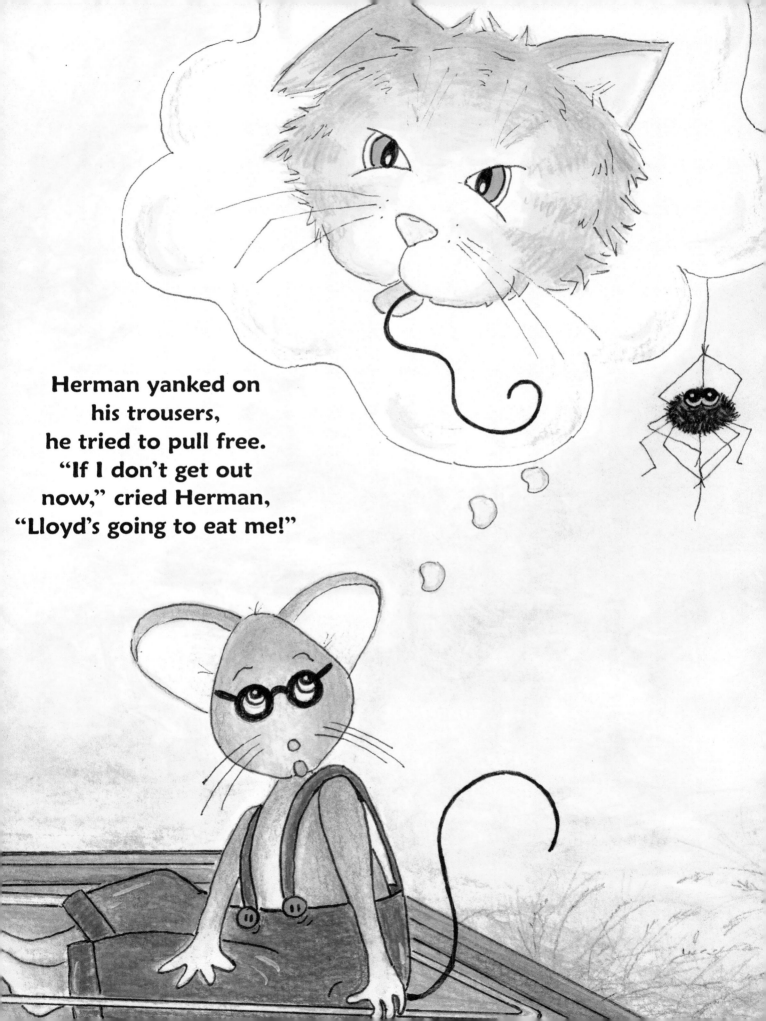

Herman yanked on
his trousers,
he tried to pull free.
"If I don't get out
now," cried Herman,
"Lloyd's going to eat me!"

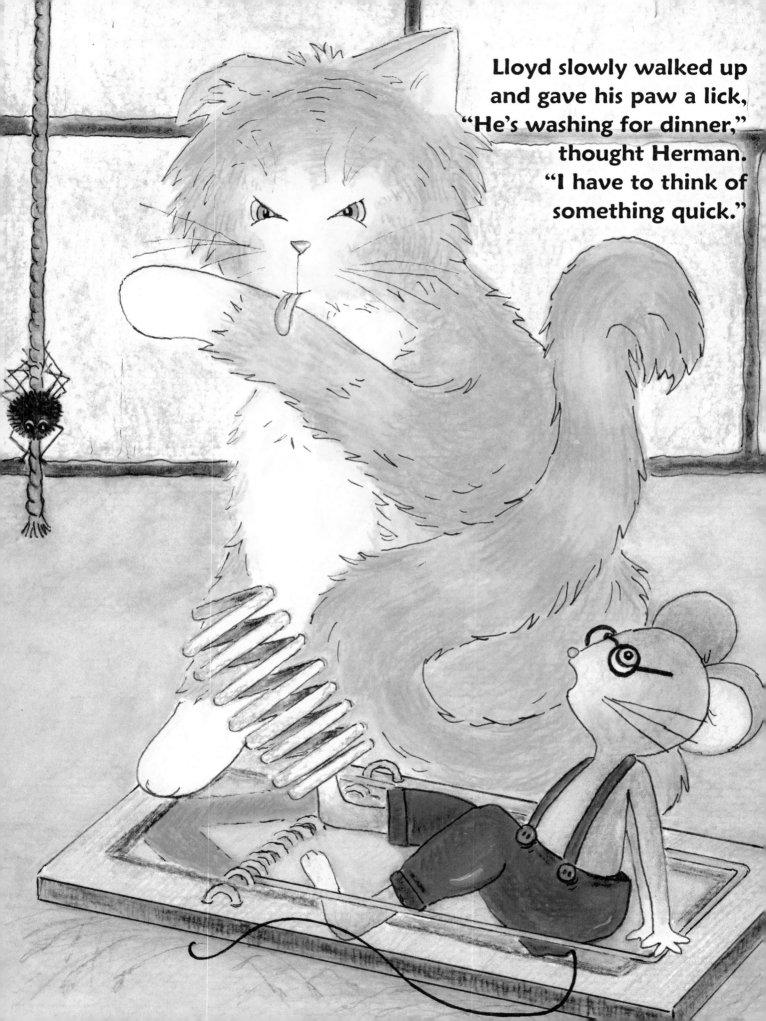

Lloyd slowly walked up
and gave his paw a lick,
"He's washing for dinner,"
thought Herman.
"I have to think of
something quick."

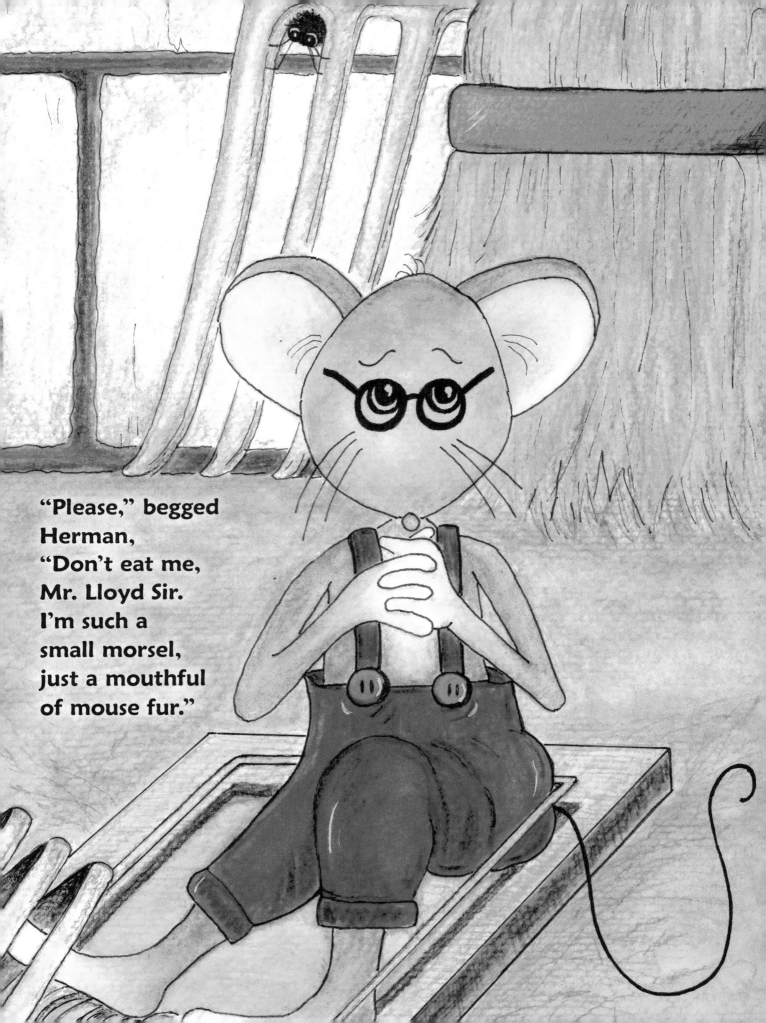

"Please," begged
Herman,
"Don't eat me,
Mr. Lloyd Sir.
I'm such a
small morsel,
just a mouthful
of mouse fur."

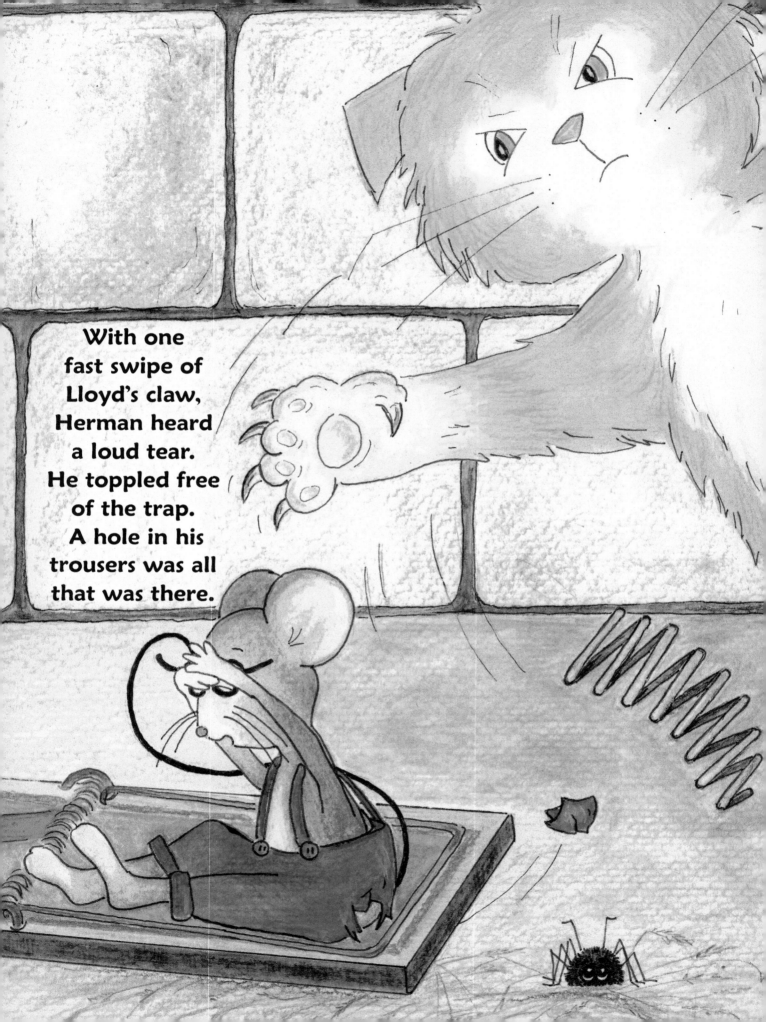

With one fast swipe of Lloyd's claw, Herman heard a loud tear. He toppled free of the trap. A hole in his trousers was all that was there.

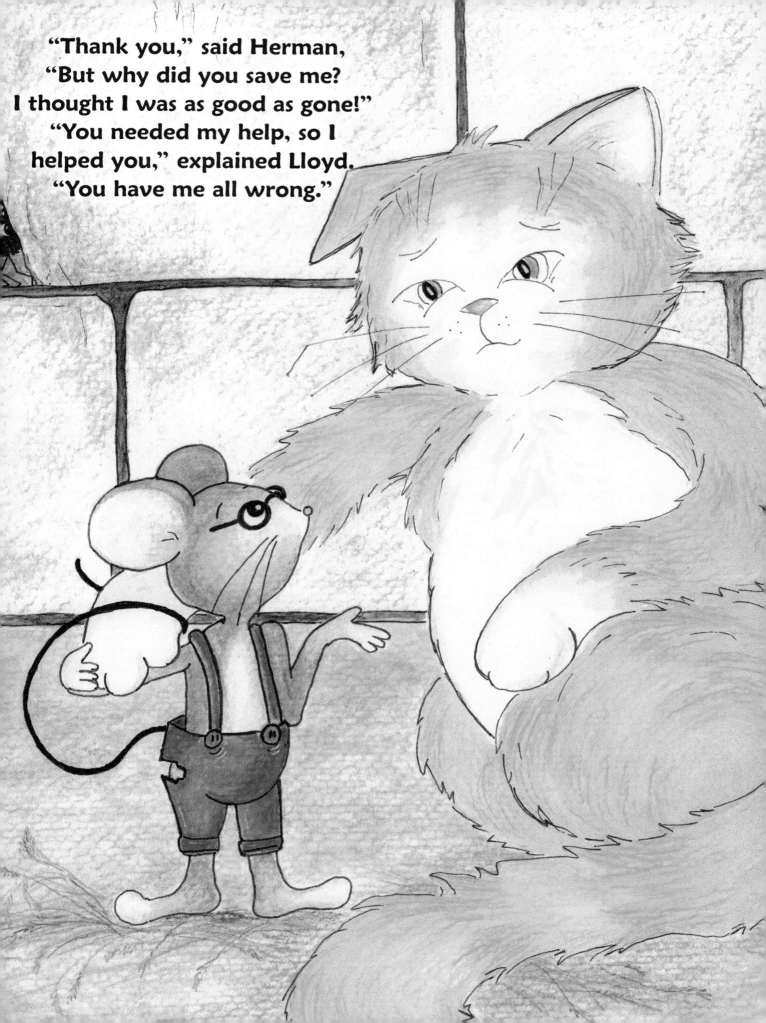

"Thank you," said Herman,
"But why did you save me?
I thought I was as good as gone!"
"You needed my help, so I
helped you," explained Lloyd.
"You have me all wrong."

"I was found in the snow one winter as a kitten,
the farmer brought me here.
That's the reason (from the frost) no scary fights,
that I have only one ear."

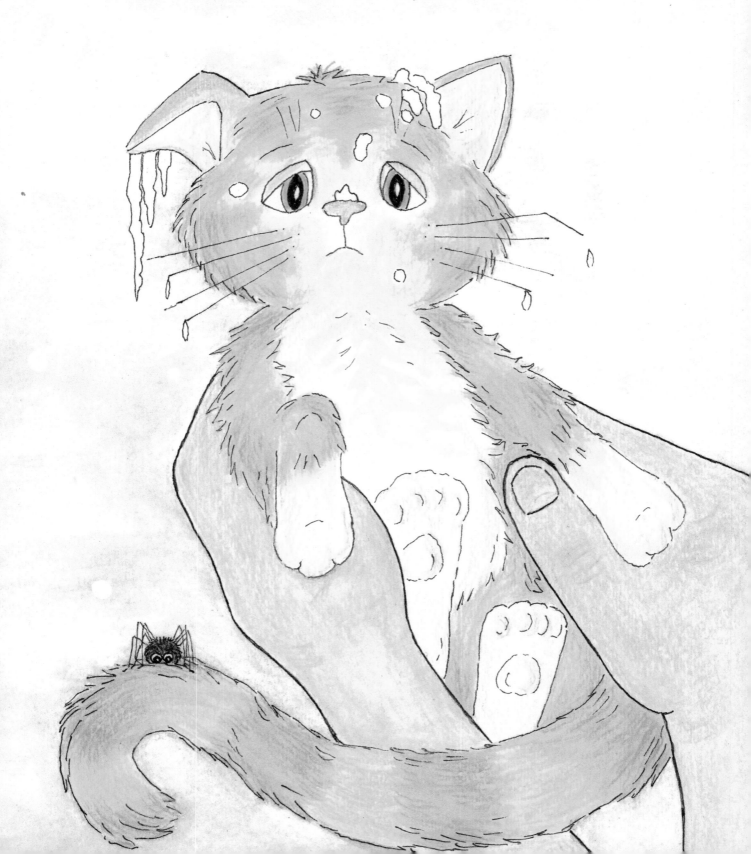

"The farmer taught me kindness.
She has a very big heart.
To love, be friends
even if you are different,
that's the best part."

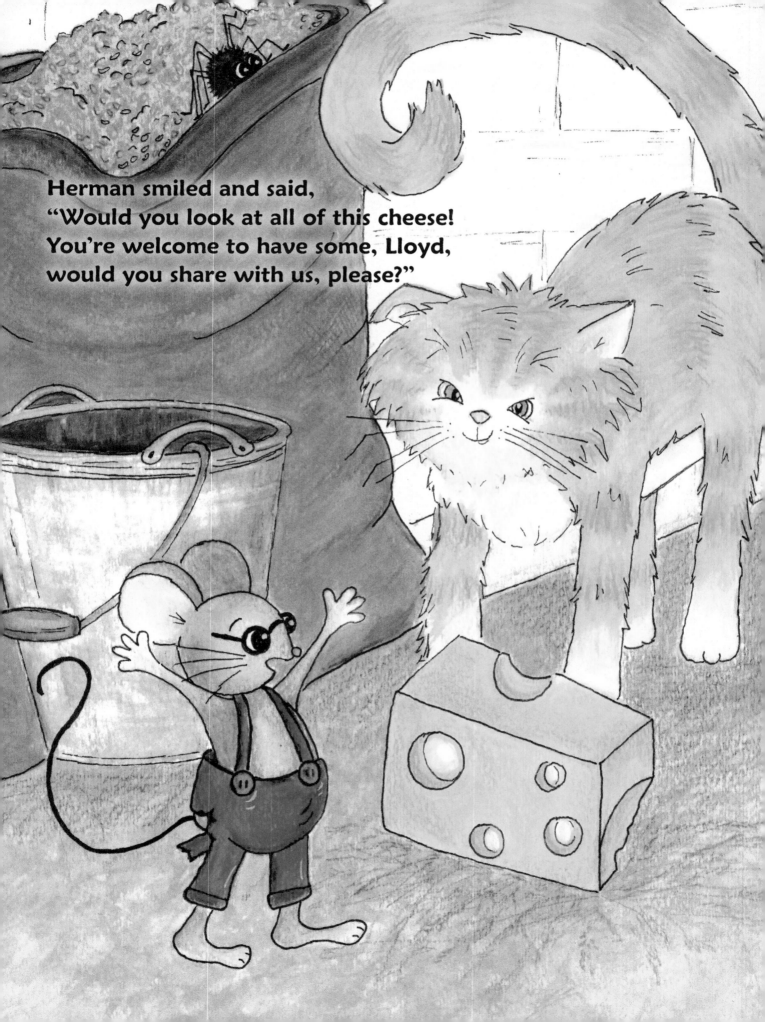

Herman smiled and said,
"Would you look at all of this cheese!
You're welcome to have some, Lloyd,
would you share with us, please?"

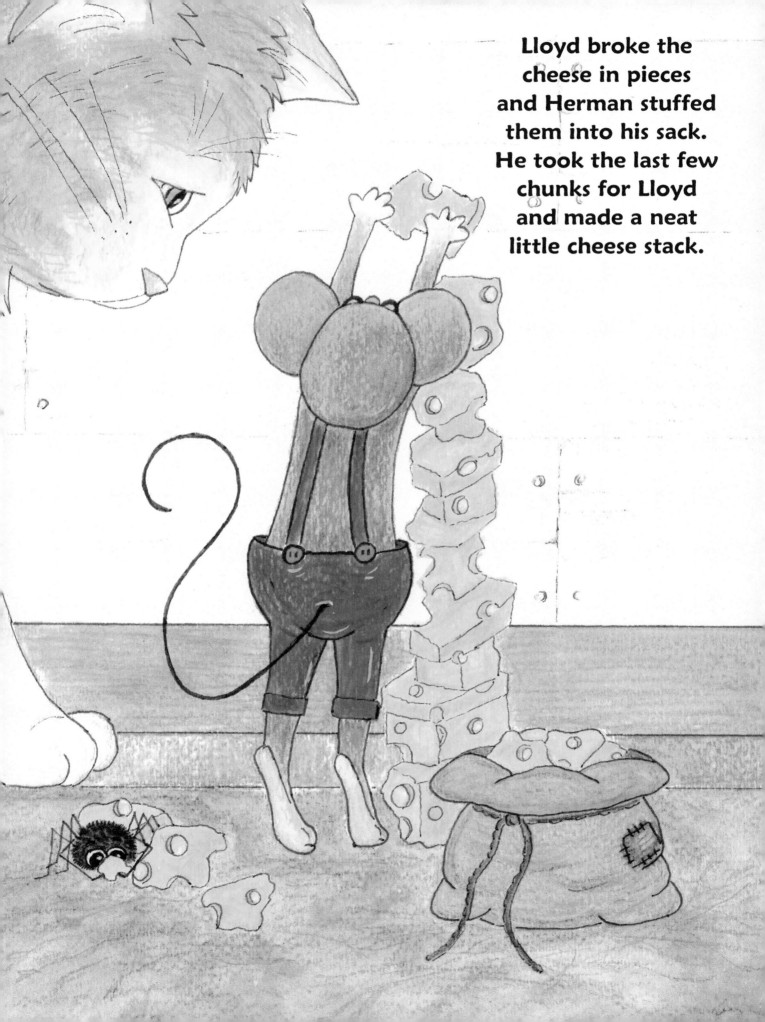

Lloyd broke the cheese in pieces and Herman stuffed them into his sack. He took the last few chunks for Lloyd and made a neat little cheese stack.

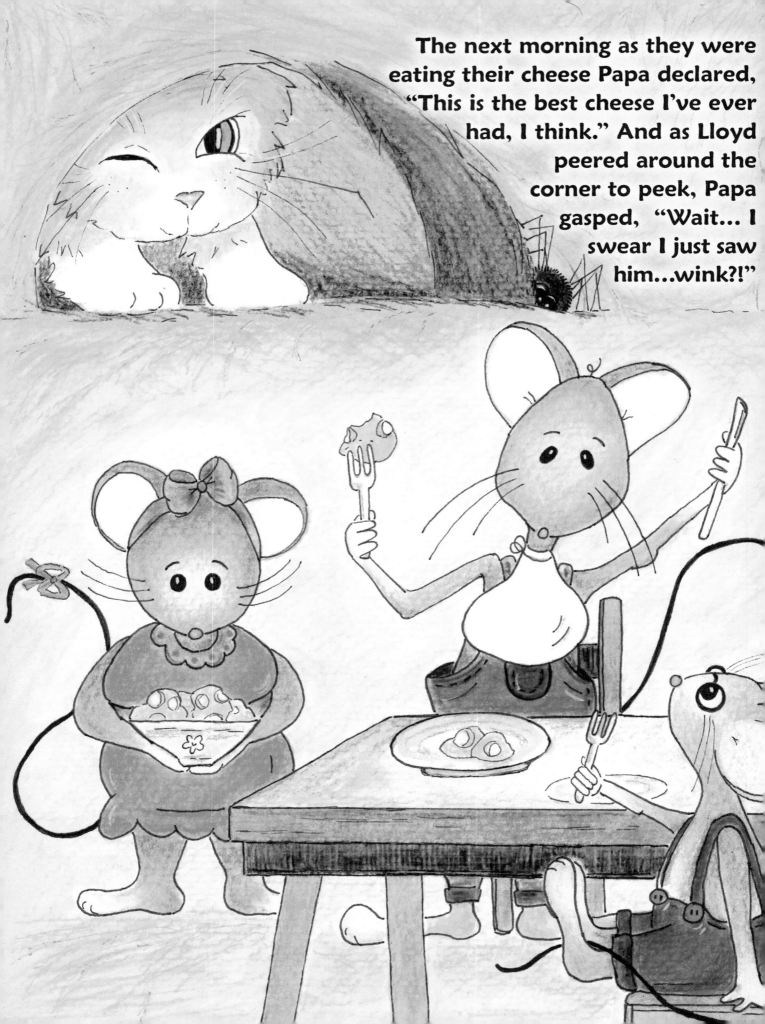

Herman the Mouse
is very, very smart,
because of what he
learned in the end:
No matter how
different someone is,
anyone can be a friend.

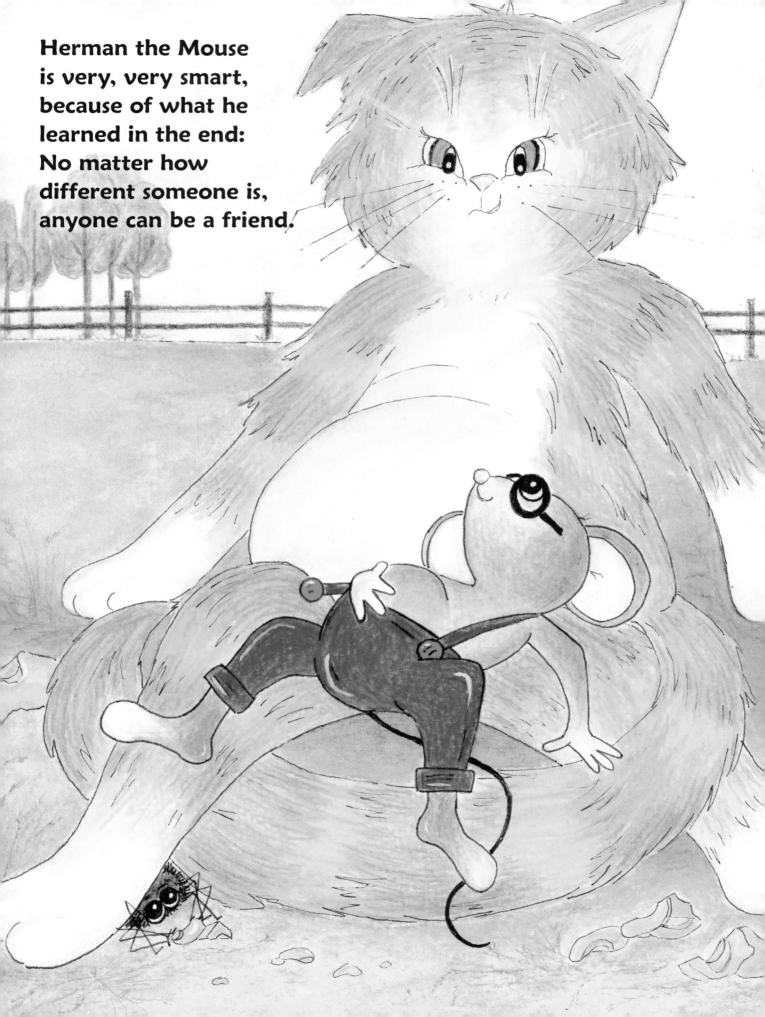

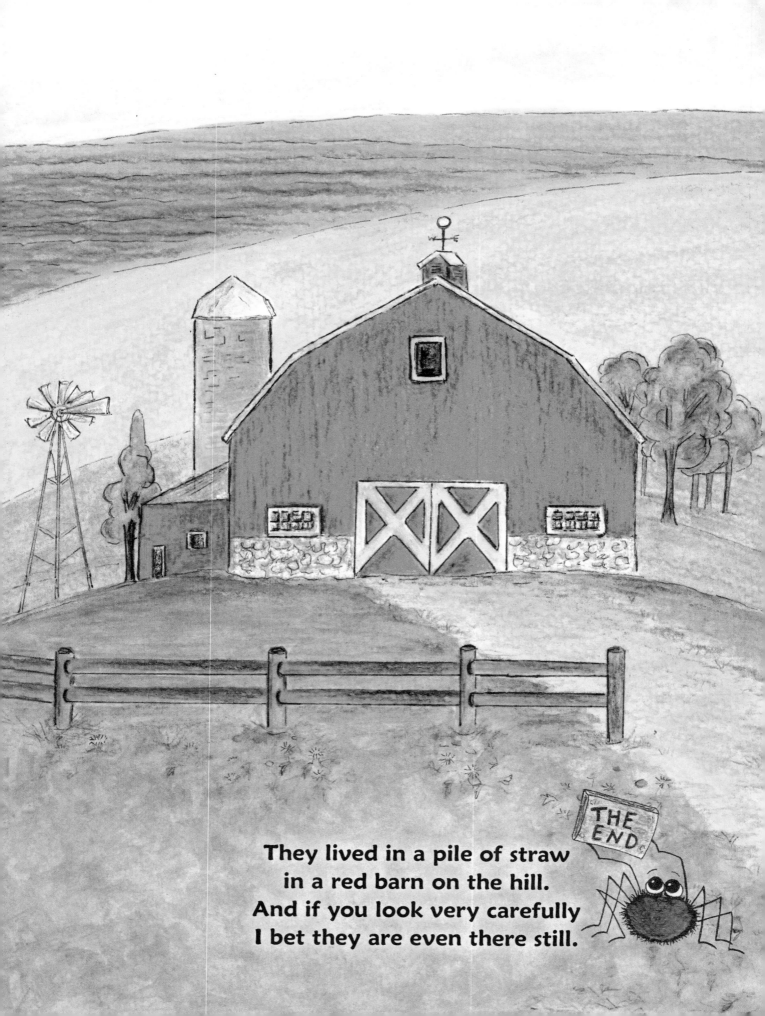

They lived in a pile of straw
in a red barn on the hill.
And if you look very carefully
I bet they are even there still.